The Polar Bear Waltz

and Other Moments of Epic Silliness

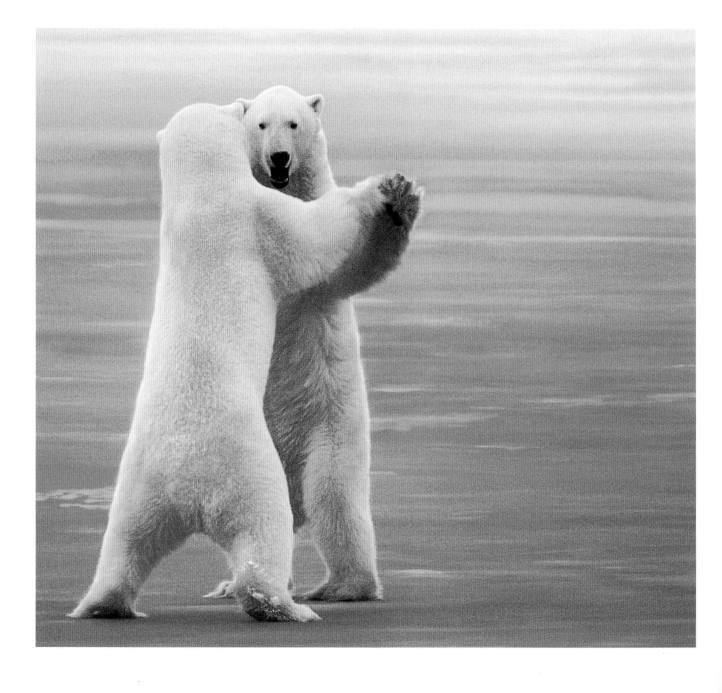

The Polar Bear Waltz

and Other Moments of
Epic Silliness

Classic Photographs from
Outside *Magazine's "Parting Shot"*

from the editors of *Outside*

W. W. NORTON & COMPANY
NEW YORK ● LONDON

RS

The text of this book is composed in Fournier with the captions and display set in Meta

Composition by BTDNYC

Book design and photo sequencing by BTDNYC

Production manager: Andrew Marasia

Library of Congress Cataloging-in-Publication Data

The polar bear waltz and other moments of epic silliness / from the editors of Outside magazine.

 p. cm.

 "Outside book."

 ISBN 0-393-32398-6 (pbk.)

 1. Photography, Humorous. 2. Outside photography. I. Outside (Chicago. Ill.)

 TR679.5 .P65 2002

 779'.9765—dc21 2002016679

W. W. Norton & Company, Inc., 500 Fifth Avenue, New York, N.Y. 10110

www.wwnorton.com

W. W. Norton & Company Ltd., Castle House, 75/76 Wells Street, London W1T 3QT

5 6 7 8 9 10

Introduction

Hampton Sides

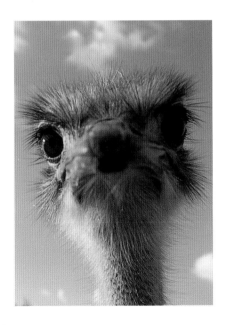

PHOTOGRAPHERS, REALLY GOOD PHOTOGRAPHERS, aren't like you and me. They perceive the world differently. They catch things—subtle situations, funny contrasts, strange plays of light—that others would miss. They hunt for the extraneous, the unexpected, the one frame of pleasing whimsy in the drab matte of the predictable.

This is especially true of action photographers who work in the outdoors. They're the jazz musicians of their craft, for the conditions in which they work force them to improvise constantly. Unlike their colleagues in the studio, they have to contend with subject matter that's in perpetual flux: changing light, wind, shadows, weather, seasons. A beetle may wander across the lens at the most inopportune moment; jungle humidity may ruin the film; a bull elephant may open his ears wide and chase the interloping photographer from his piece of the veld.

Not only do outdoor photographers have to master the usual technical aspects of the job—filters and f-stops and the like—but they also have to adopt a certain whatever-comes attitude that's distinctly at odds with the control-freakism typical of most indoor shoots. They become skilled at turning chaos into a virtue. Their job tends to be characterized by long stretches of nothing happening punctuated by intense bursts of everything happening at once. At those moments, they have to work on pure instinct, sometimes at furious speed. As the adage goes, "Shoot now, compose later."

The results of these frenetic sessions are necessarily mixed, of course. The photographer often has no idea what he or she has captured until the results appear in the darkroom. Often it's merely dross. Every once in a while, though, something rare and magical emerges. Not just technically proficient photography, not just beautiful images in a conventional sense, but a charmed moment captured on film: a felicitous surprise, an absurd juxtaposition, an unforeseen accident of perspective. Such moments are all about serendipity—the right photographer in the right place at the right time, with a finger on the trigger. And though these moments may seem like bits of dumb luck, the great action photographer has a knack for lucking into them.

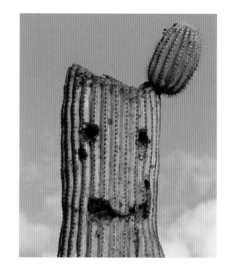

"Timing is everything in landing these kinds of images," says *Outside*'s photo editor, Rob Haggart. "The trick is having the sixth sense to anticipate a moment that's about to happen."

This book is a collection of those serendipitous moments, captured by some of the finest outdoor photographers in the field. They're taken from more than two decades of "Parting Shot," a monthly page in *Outside* magazine. They're scenarios of glancing humor, arresting images from the far-flung world that convey a wry shade of emotion somewhere between a giggle and a grin. In many cases the situations are so dreamlike or outrageous that they beg for more explanation. Yet, at the same time, the viewer somehow understands that captions would be a letdown, because the imagination supplies a better narrative.

In a sense, these images should also be understood as rimshots, as amusing duck tails, for the "Parting Shot" is always the literal and figurative finale of the magazine, occupying the last page. Month after month, it's the note on which the magazine ends.

The graceful exit, it seems to me, is a dying art. No one seems to know how to end things with style or humor anymore. From our films to our love relations, we increasingly tend toward garish pyrotechnics or sappy melodrama when it's time to say farewell. Or just the opposite—we act as though the ending isn't happening, and fail to give it due significance. Trains seldom come with proper cabooses these days, and we all know that isn't right.

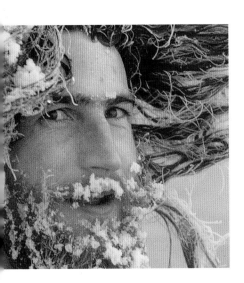

The stylish good-bye is a problem every magazine has to grapple with. What should the editors do with their caboose slot? How does one sum up a magazine with elegance and concision? How does an issue go out, not with a bang exactly, but with something striking and memorable that echoes the spirit of the preceding pages? A few grandiose editors have used the last page as a soapbox, a place to maunder on about this or that. Some magazines farm it out to crossword puzzlesmiths. Others give up entirely, and sell the last page to the highest advertising bidder.

Outside had a better idea. "Parting Shot" began in the June/July issue of 1980, with an improbable photograph from the Afghanistan-Pakistan border by Terrence Moore (page 89). In the image, a runner in typical marathoner's garb is jogging through the Khyber Pass while a pair of rifle-toting mujahideen fighters look on. The photograph raises a world of questions. What was the runner doing there? What did the fighters think of this odd specimen of Homo sapiens?

Moore's photo nicely set the tone for the years to come. Ever since, *Outside* has never been at a loss for its grand finale. For more than twenty years, and more than 240 images, "Parting Shot" has been an exceedingly popular signature of the magazine. *Outside*'s editors sometimes had to comb the world for these images, but just as often the photos came in over the transom, from magnificent photographers who gamely got into the spirit of things. In some cases, the magazine also published material from amateurs who happened to capture a particularly striking or funny moment on film and sent it into our offices on a lark.

For twenty-plus years, readers have consistently turned to the back page to get their fix of flying dogs and gawking ostriches, of lions eating cameras, of people getting themselves into outrageous fixes and outlandish predicaments that seem virtually impossible to get out of. They're the kind of photos that tend to produce an instantaneous reaction in the viewer. They tell stories that end, often as not, in a kind of visual punch line, a hook, a sight gag. And nearly always, a few seconds after the initial visceral response wears off, a secondary question comes flooding in: How did the photographer capture this image? What confluence of timing, luck, far-flung travel, and strenuous effort led to snapping this photo?

Among its many strengths, "Parting Shot" injects a note of much-needed levity into the world of nature photography. It's safe to say that lakes of purple ink have been spilled by outdoor writers, and outdoor photographers have been similarly susceptible to overly earnest depictions of nature's grandeur. The natural world is any number of things—graceful, inspiring, ruthless, tough—but it is also, we should never forget, funny. A realm of whimsical interactions and odd creatures and strange tricks of light.

As an editor and a writer for *Outside*, I've been lucky to work with several of the photographers whose pictures appear in this book. To watch them do their thing in the field is a joy and, sometimes, a laugh riot. The late Dugald Bremner (page 37) was a good friend of mine. He was an inveterate river rat from Flagstaff, Arizona, who traveled the world with his camera, and, it must be added, he did a damn good Dana Carvey–style imitation of George H. W. Bush. We knocked around together in Chiapas, Mexico, and then, several years later, floated down the Colorado through the Grand Canyon in his dory. A few years ago, Dugald drowned while kayaking in a swift, boulder-choked stream in California's Sierra Nevada.

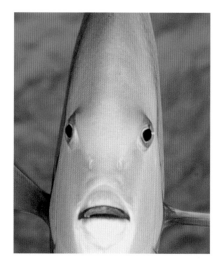

Like so many of the photographers in this book, Dugald had an intuitive ability to discern things that were unapparent to the average eye—like mine. Truly, he had the gift. One afternoon we were hiking in a slot canyon when he suddenly grabbed his camera, as though something had spooked him. I looked in the direction he was shooting, somewhere high up in the rimrock, and said, "Dugald, what is it? There's nothing there. You're wasting film."

"Wouldn't be prudent to waste film," he said in Bushspeak, as he snapped away, happily ignoring me.

The moment passed, whatever it was, and Dugald put away his camera. Then, offhandedly, as an aside, he said, "I saw something."

The Polar Bear Waltz

and Other Moments of Epic Silliness

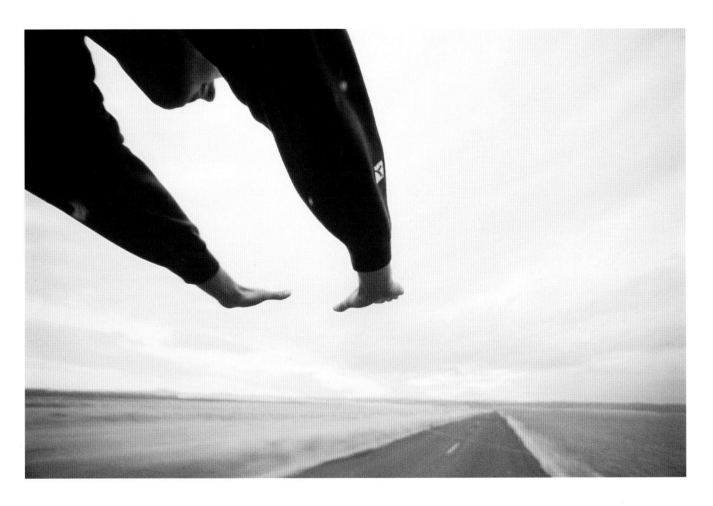

Cloverland Road, Asotin County, Washington

RICHARD HAMILTON SMITH

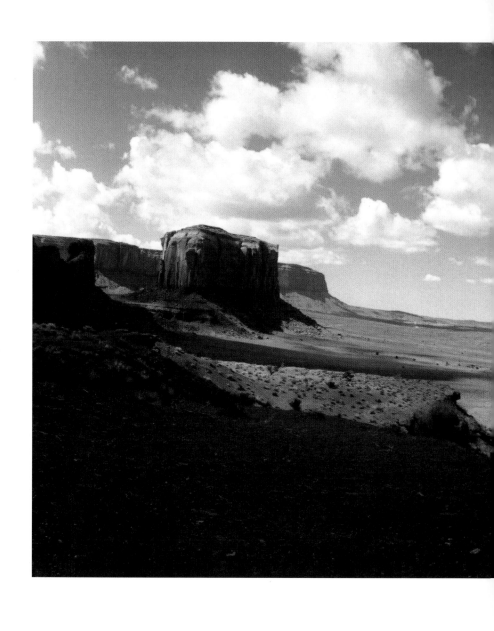

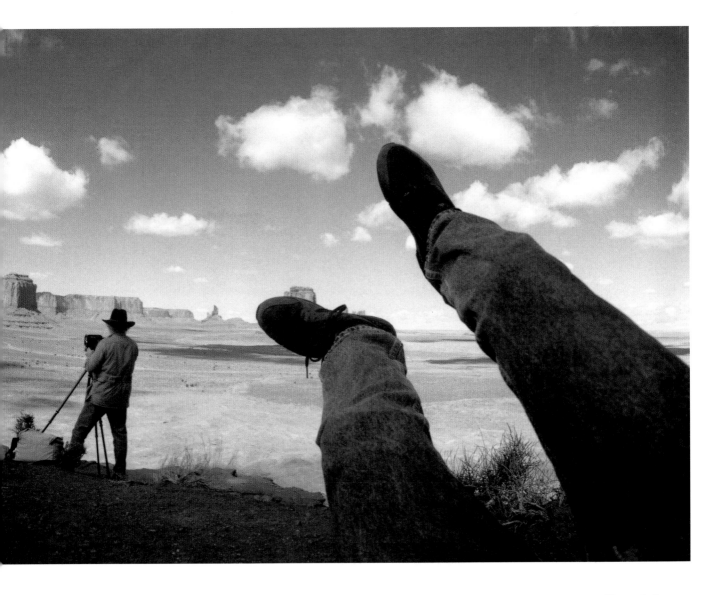

Monument Valley, Arizona

CHARLES MASON

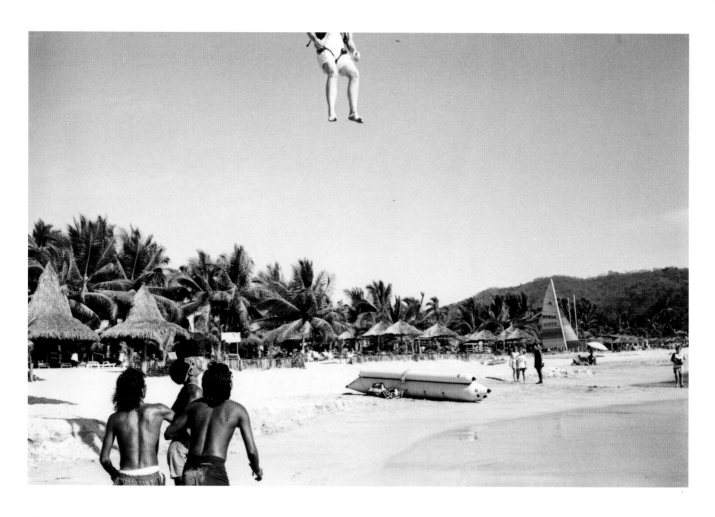

Zihuatanejo, Mexico

LLOYD ZIFF

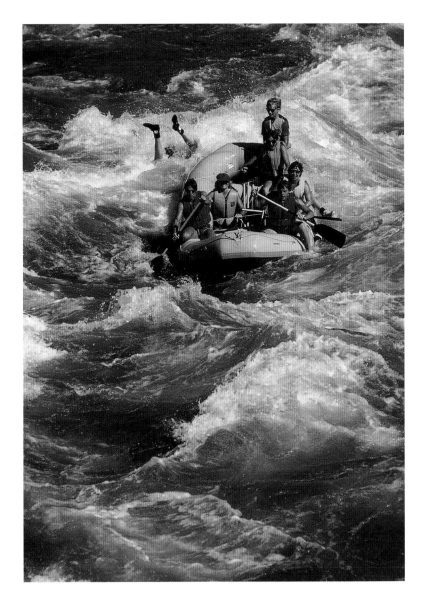

South Canyon, Colorado River

DOUG LEE/PETER ARNOLD

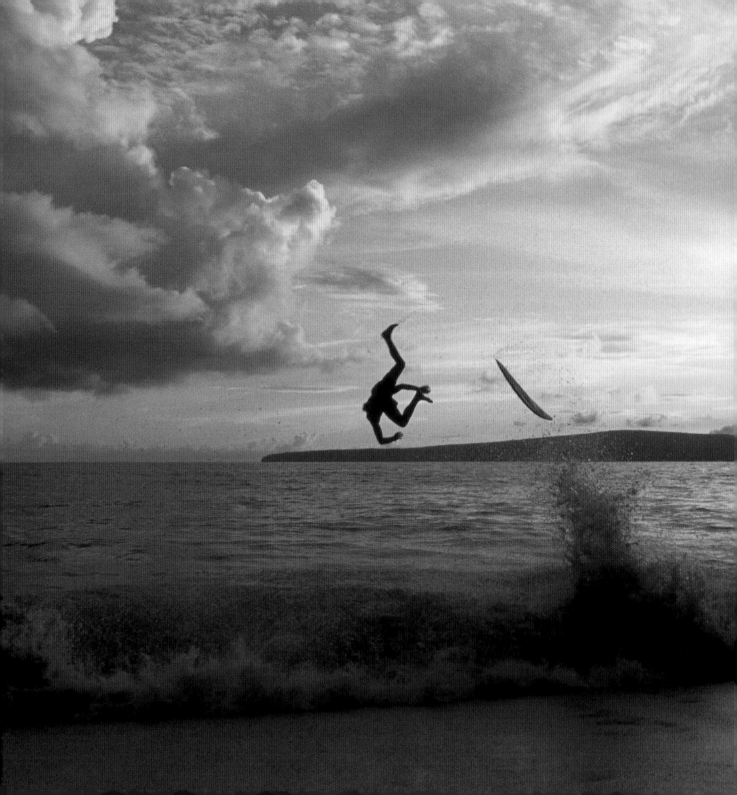

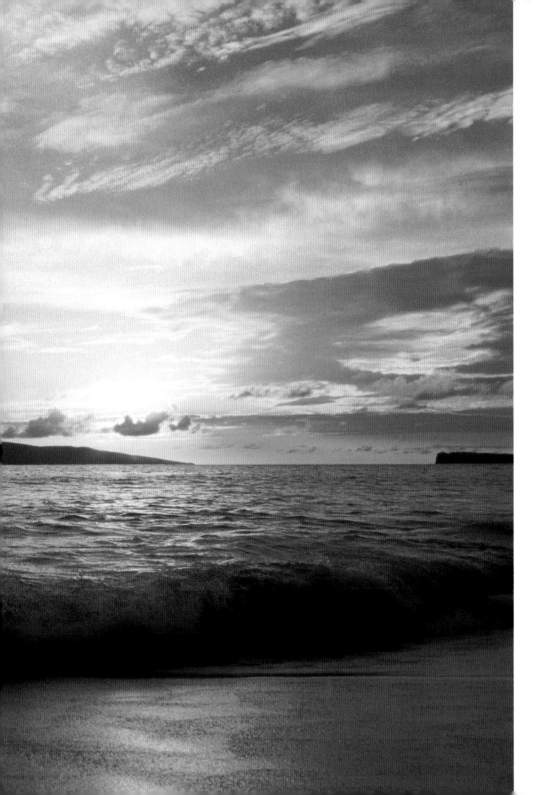

Makena Beach, Maui

SKIP BROWN

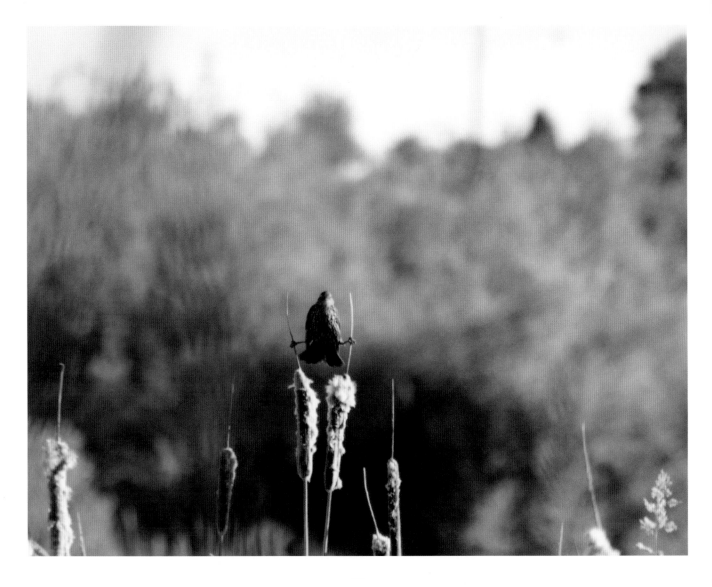

Pullman, Washington

JAMES MICHAEL DAVIES

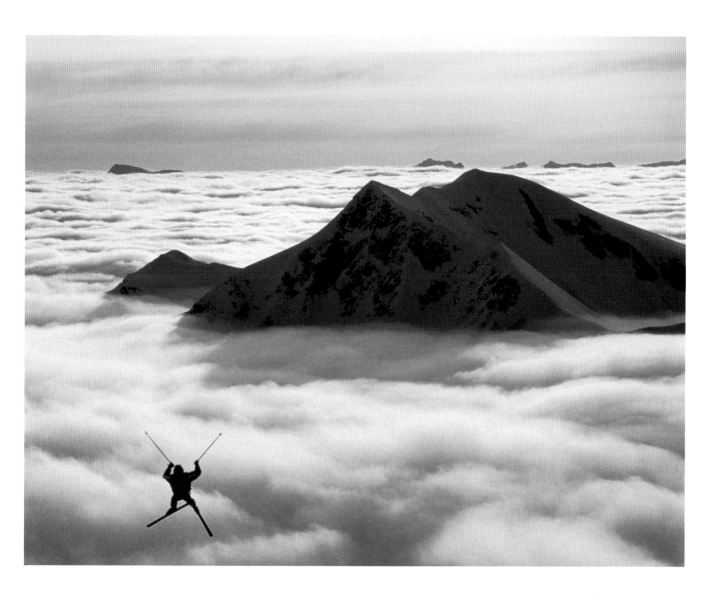

La Plagne, France
DIDIER GIVOIS/GETTY

Washington, D.C.

TERRI WEIFENBACH

**Above the
Thames Waterfront,
London**

BRENT HUMPHREYS

Sugar Bowl, California

BILL STEVENSON

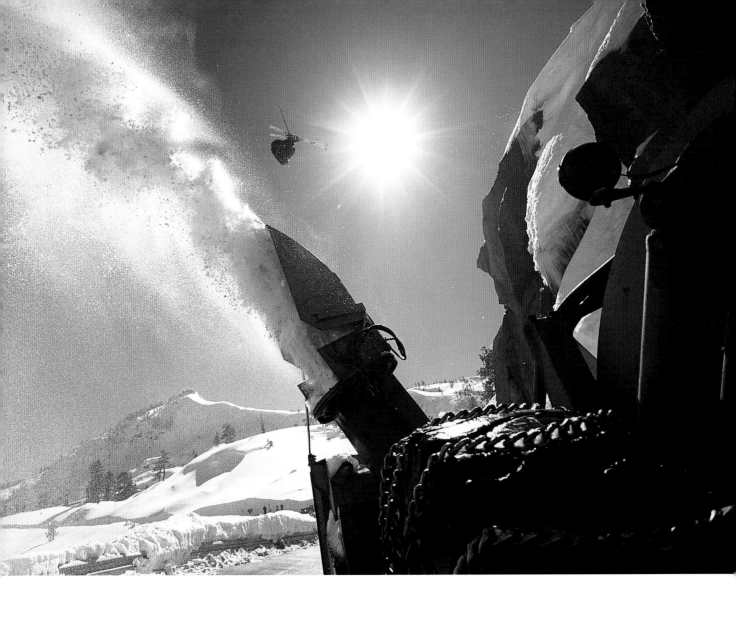

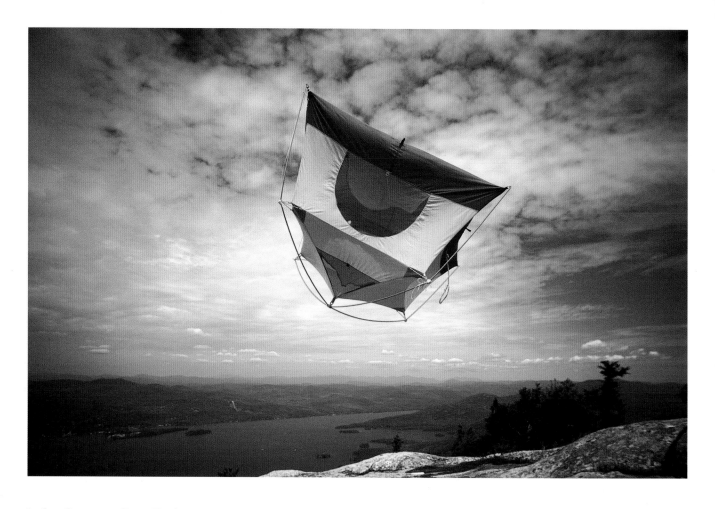

Lake George, New York

ED BURKE

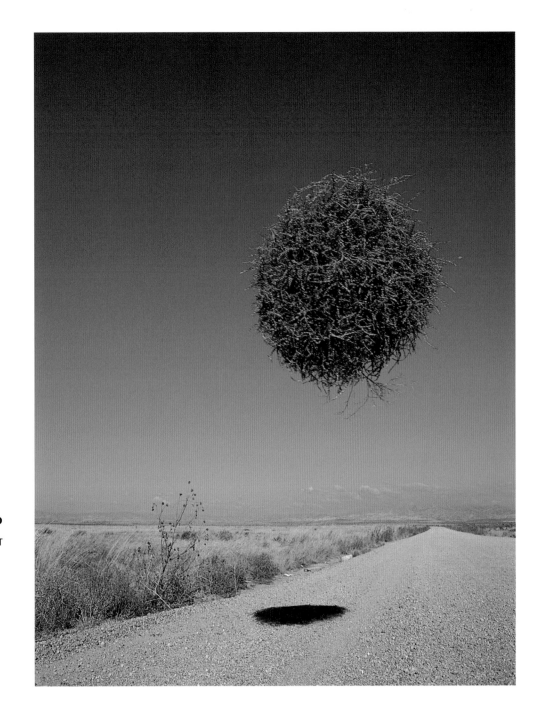

Elmore County, Idaho

WOODS WHEATCROFT

Somewhere over Illinois

TOM SANDERS

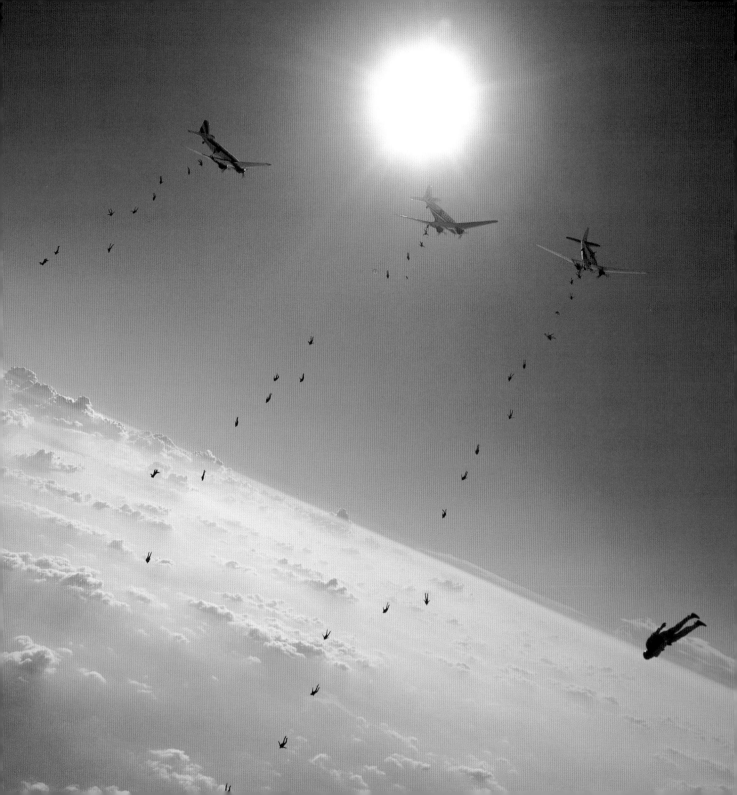

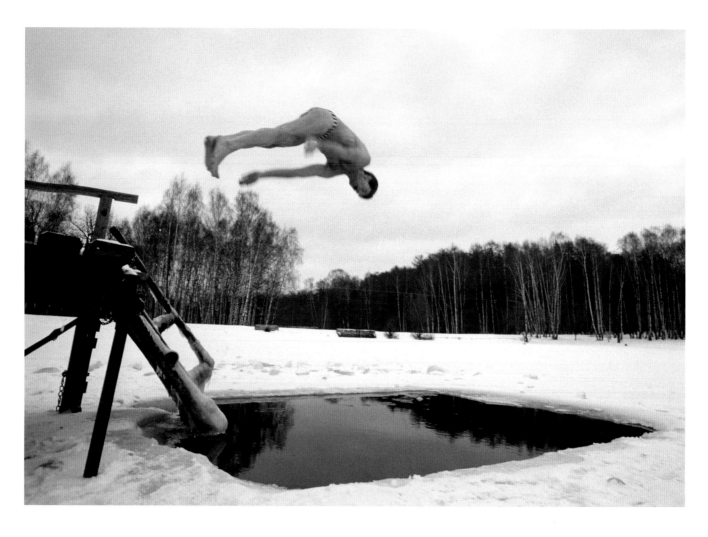

Moscow, Russia

LYNN JOHNSON/AURORA

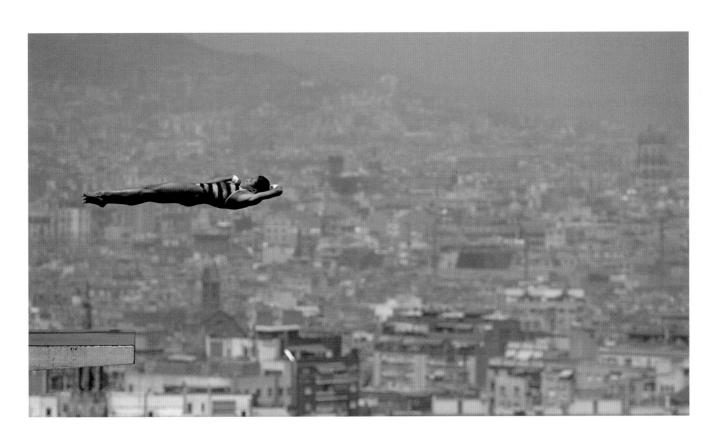

Barcelona, Spain

DAVID BURNETT/CONTACT PRESS

and Other Moments of Epic Silliness **2 9**

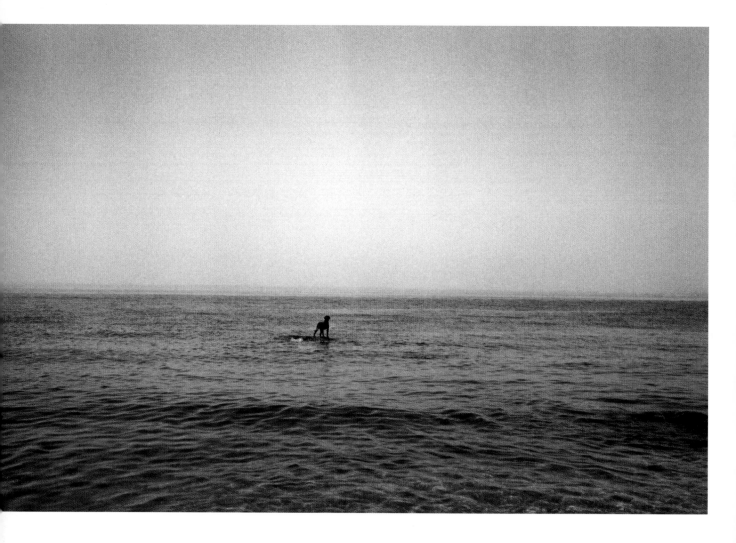

Off Orient Point, Long Island, New York

LLOYD ZIFF

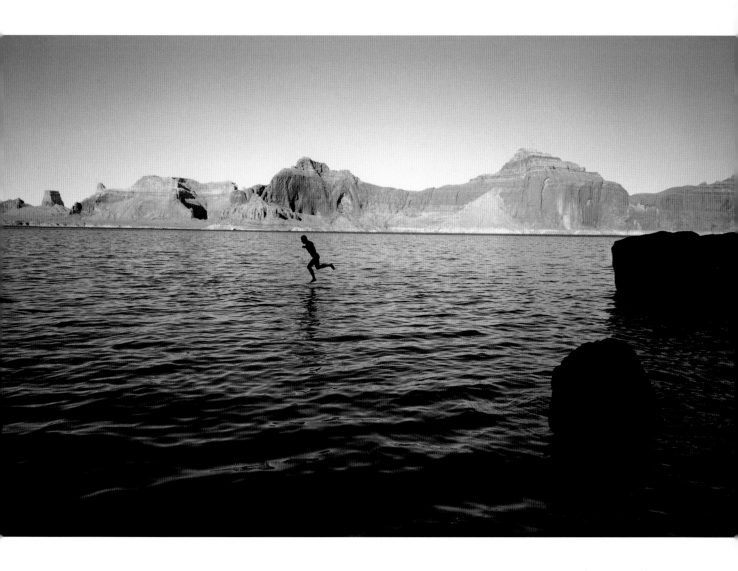

Lake Powell, Utah

SCOTT McCREERY

Matanuska Glacier, Chugach Mountains, Alaska

TOM BOL

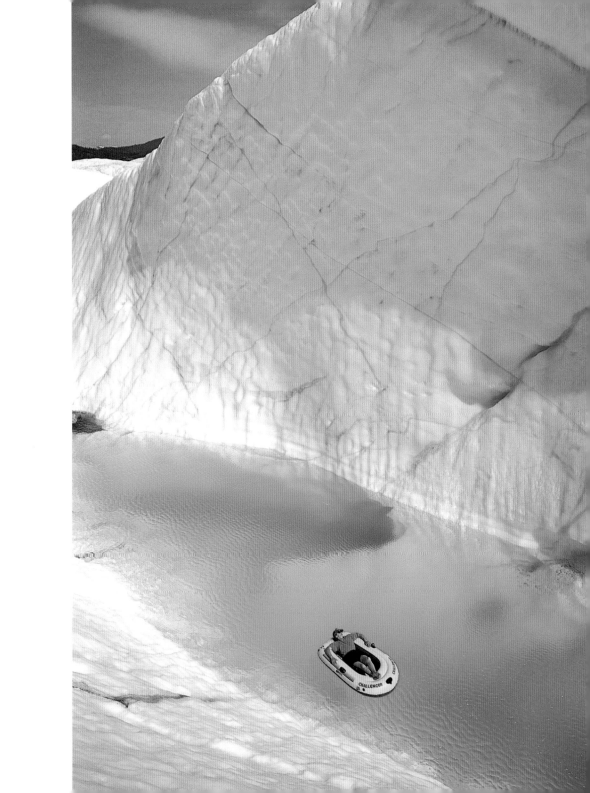

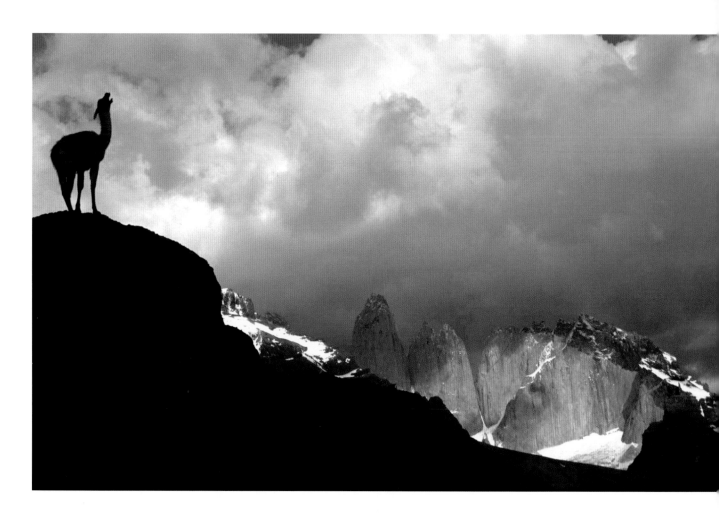

Torres del Paine National Park, Chile

STEVE GILROY

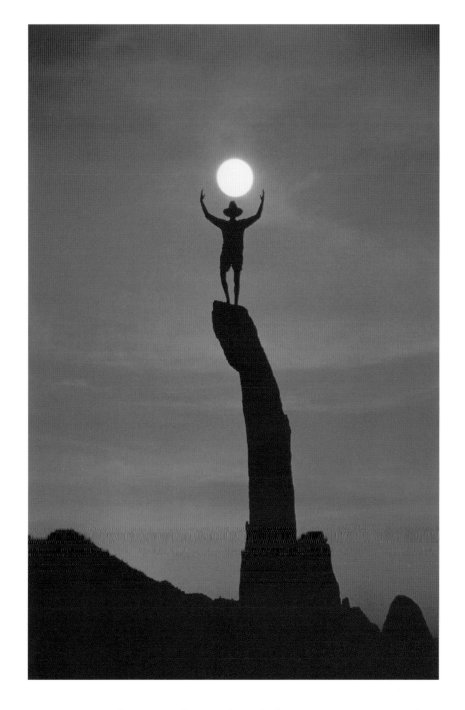

**Joshua Tree National Park,
California**

HEINZ ZAK/MAURITIUS IMAGES

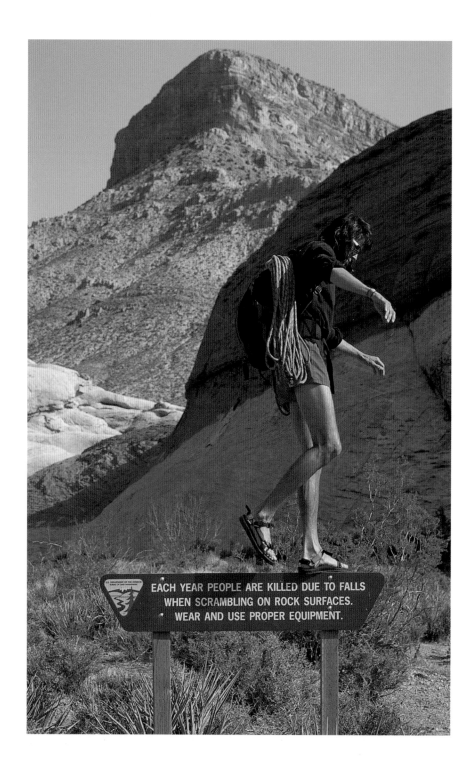

EACH YEAR PEOPLE ARE KILLED DUE TO FALLS
WHEN SCRAMBLING ON ROCK SURFACES.
WEAR AND USE PROPER EQUIPMENT.

Red Rocks, Nevada

GREG EPPERSON

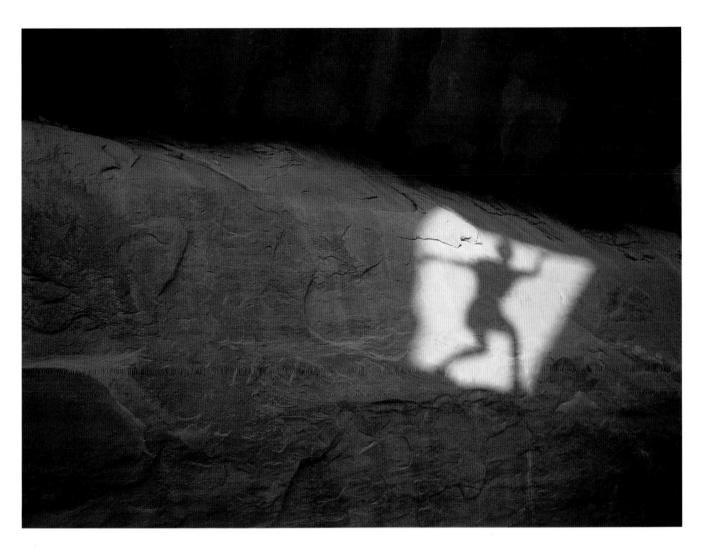

Arches National Park, Utah

DUGALD BREMNER

Joshua Tree National Park, California

DAVID BROOKS

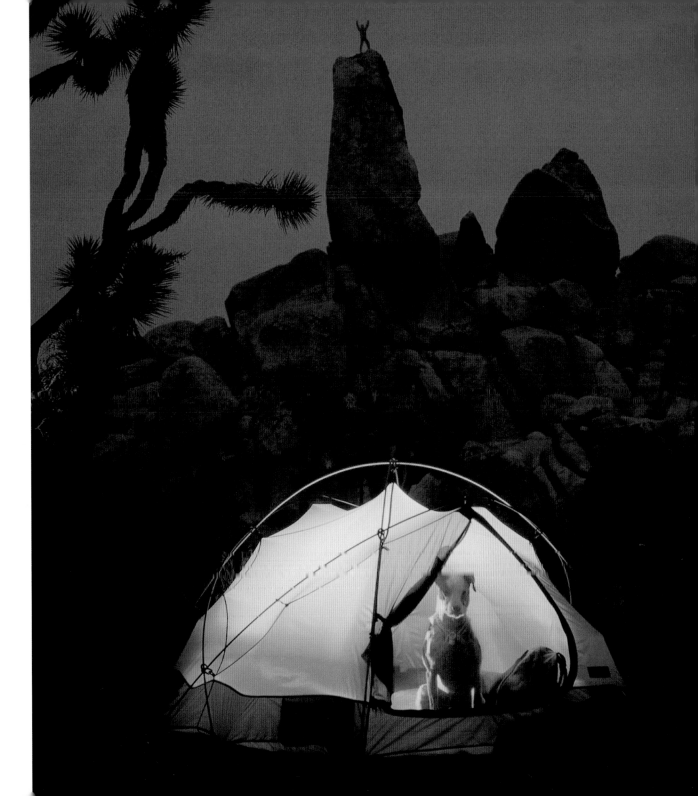

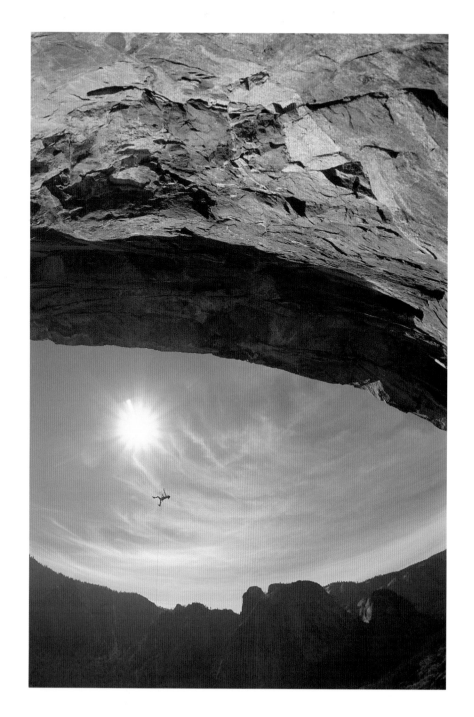

**Tangerine Trip,
El Capitan, Yosemite**

HEINZ ZAK/MAURITIUS IMAGES

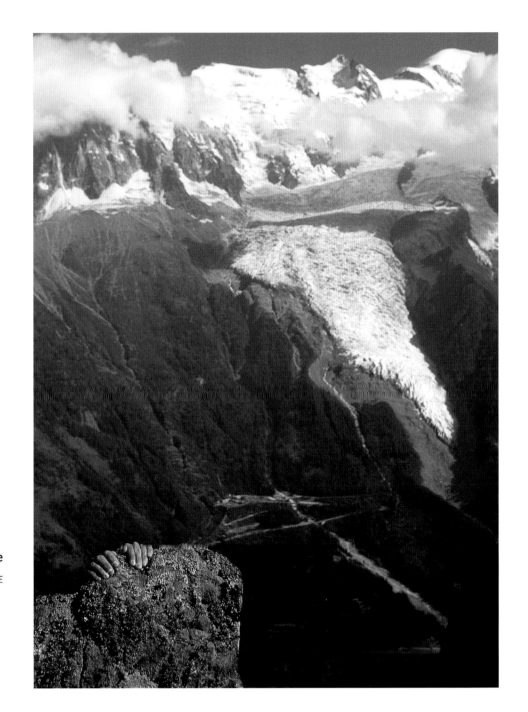

Above Chamonix, France

MONICA DALMASSO/STONE

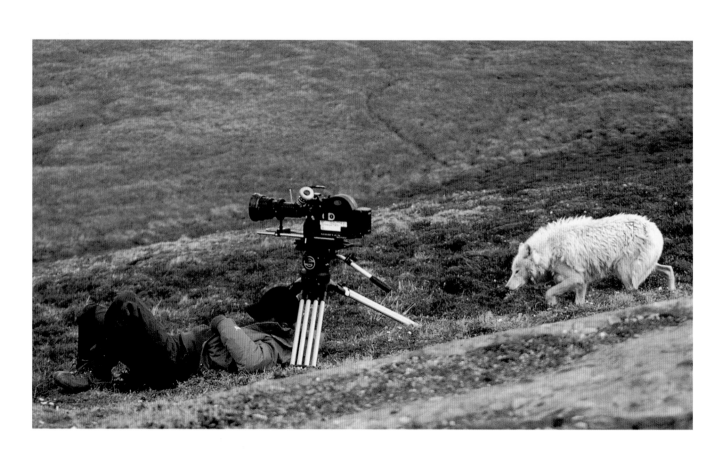

Ellesmere Island, Nunavut, Canada

STEVEN DURST/MINDEN PICTURES

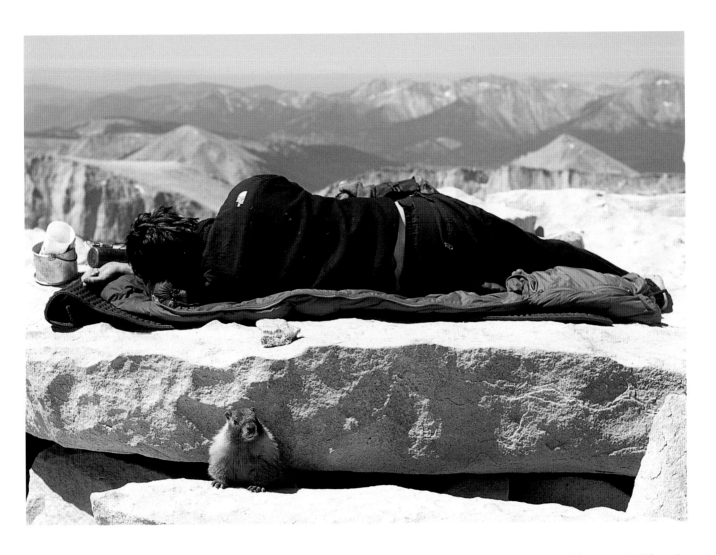

Summit of Mount Whitney, California

PAUL SOUDERS

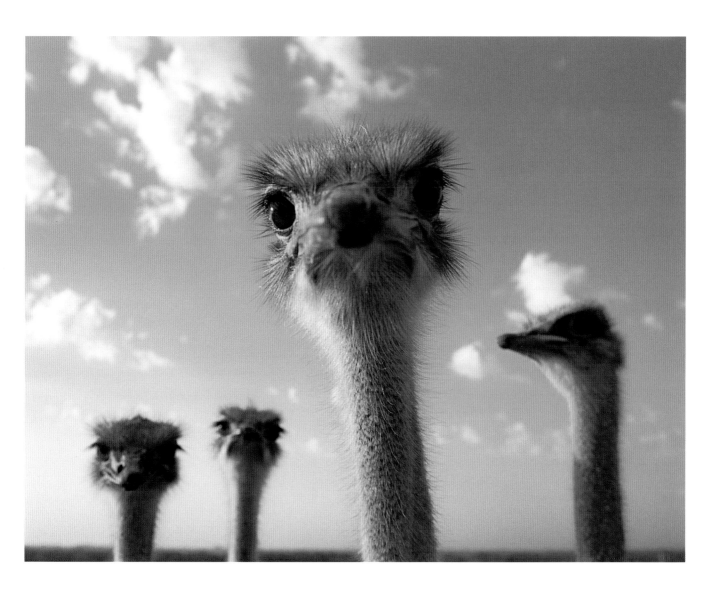

Addington, Oklahoma

KEVIN HORAN

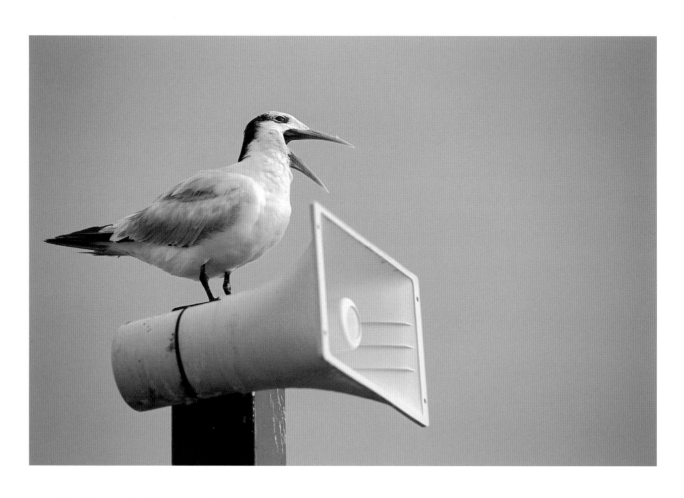

Deerfield Beach Pier, Florida

LARRY KORHNAK

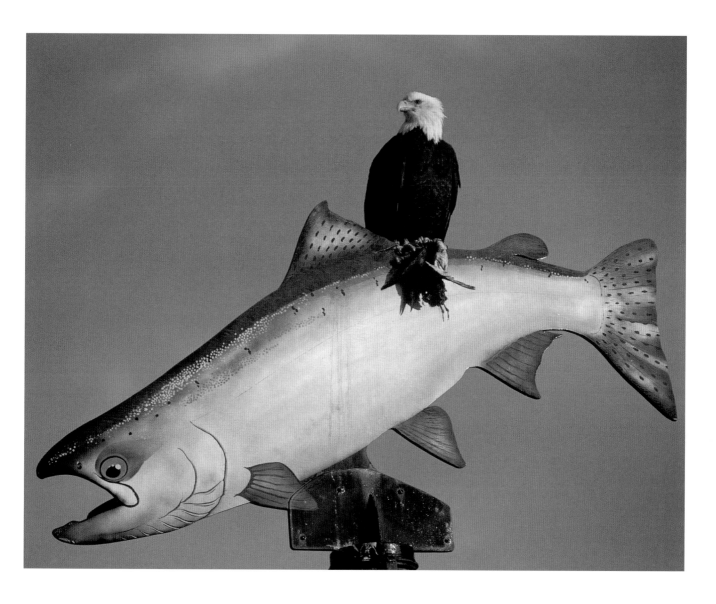

Homer, Alaska

JOHN WARDEN/ALASKA STOCK

Highway 140, Near Winnemucca, Nevada

LINDA DUFURRENA

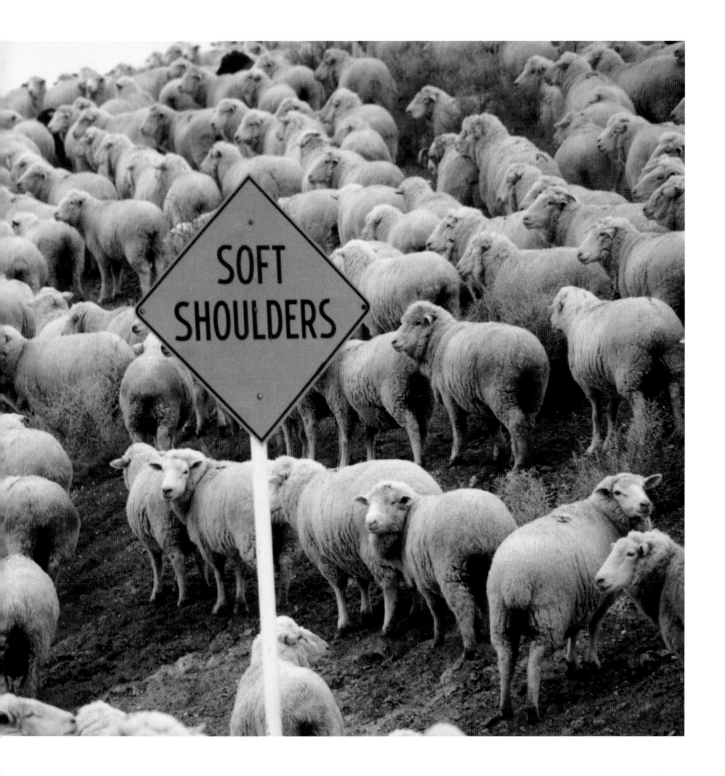

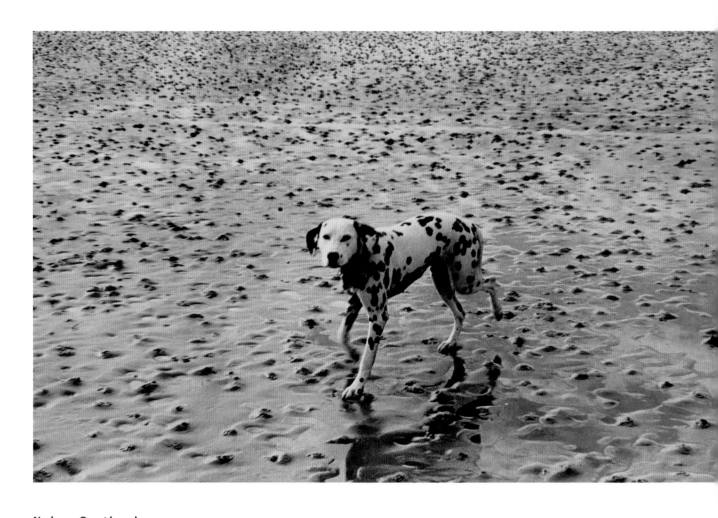

Nairn, Scotland

SPECIAL PHOTOGRAPHERS COMPANY/PHOTONICA

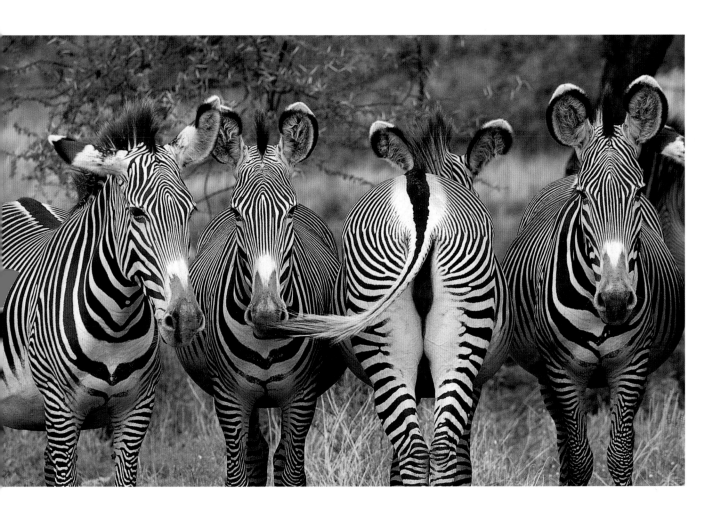

Samburu National Reserve, Kenya

MARK BOULTON/PHOTO RESEARCHERS

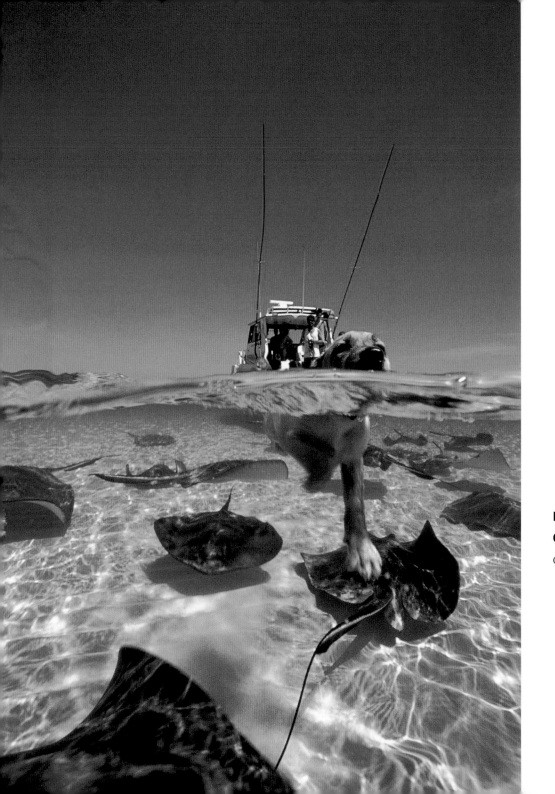

**Near Stingray City,
Grand Cayman**

CURTIS BOGGS

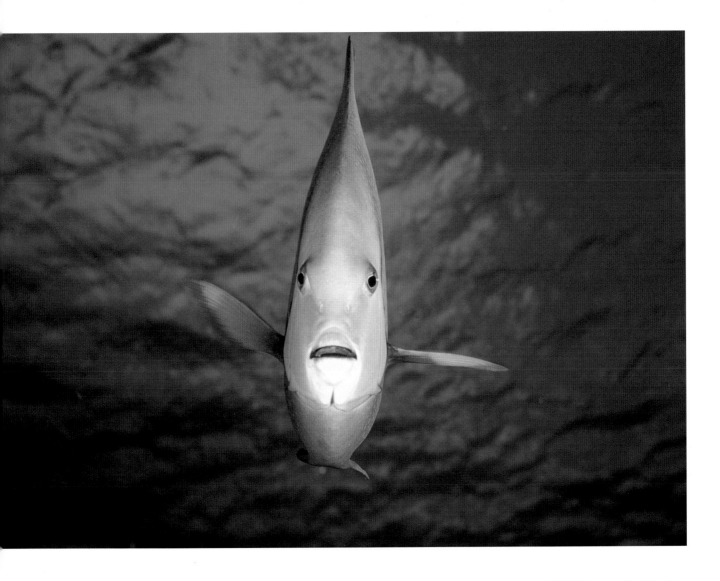

Off Cozumel, Mexico

F. STUART WESTMORLAND

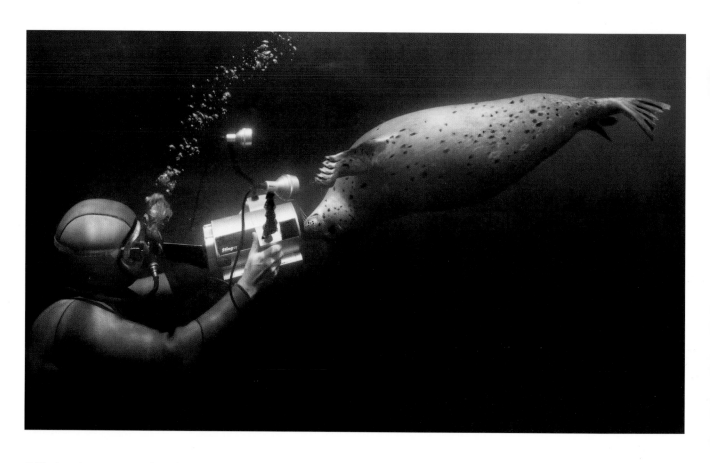

Off the Anacapa Islands, California

ERNEST H. BROOKS II

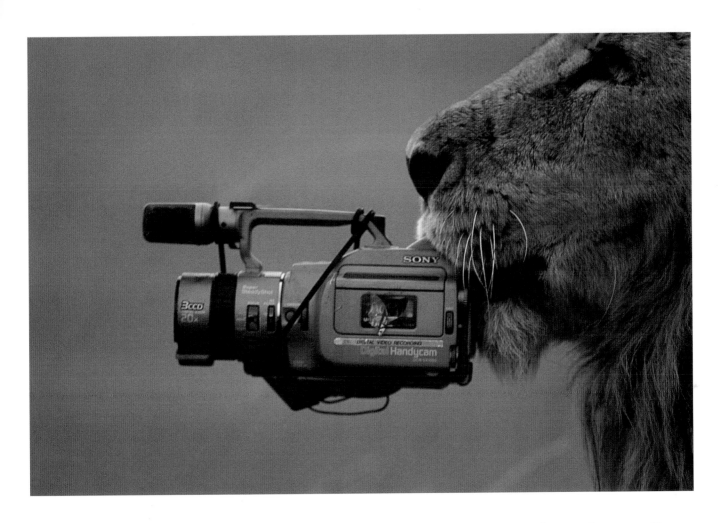

Masai Mara Reserve, Kenya

MICHAEL NICHOLS/NATIONAL GEOGRAPHIC SOCIETY

Cape Buffalo Herd, Tanzania

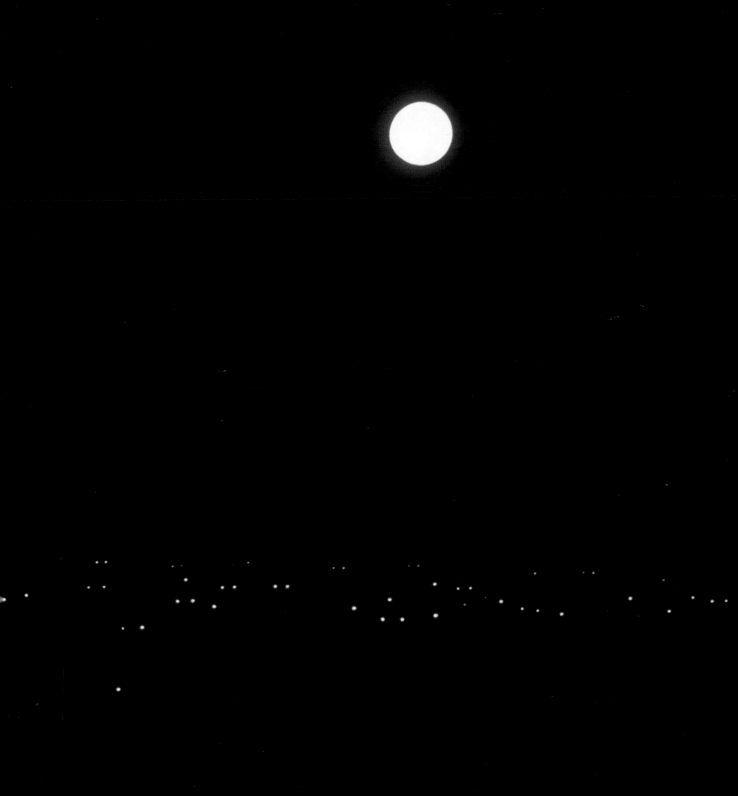

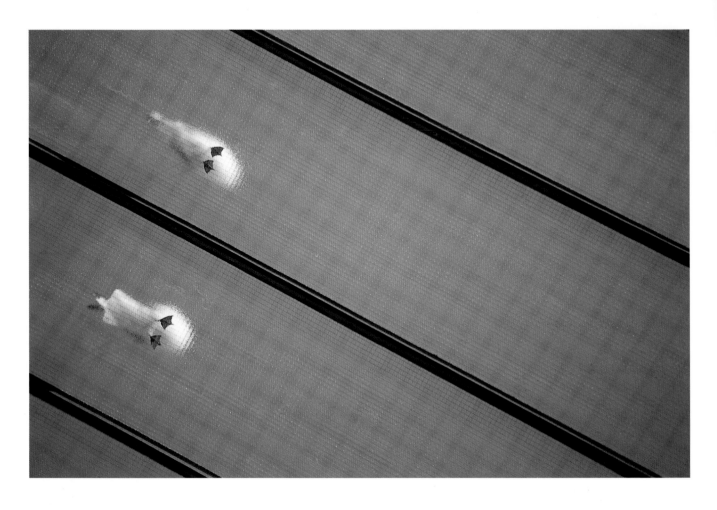

Windsor, England

SEAN ARBABI

Skeleton Coast Park, Namibia

GERALD CUBITT

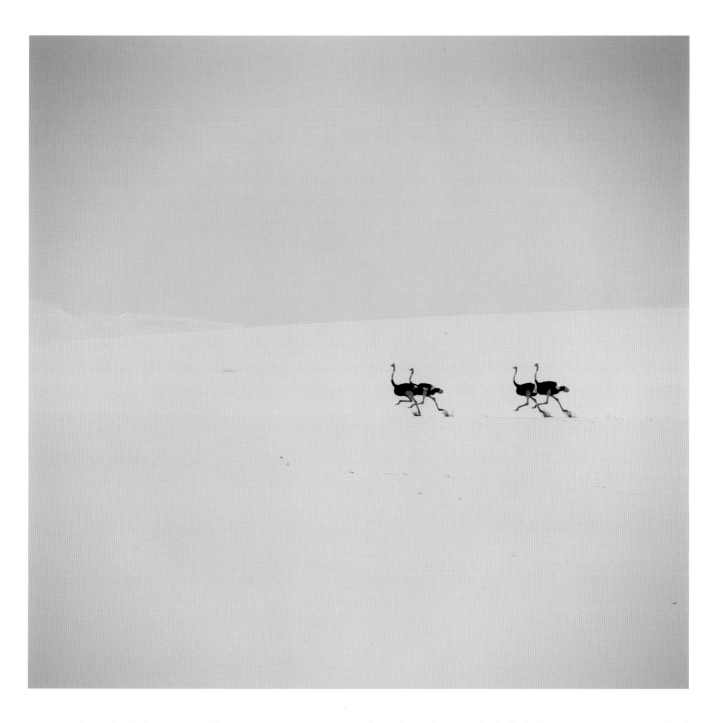

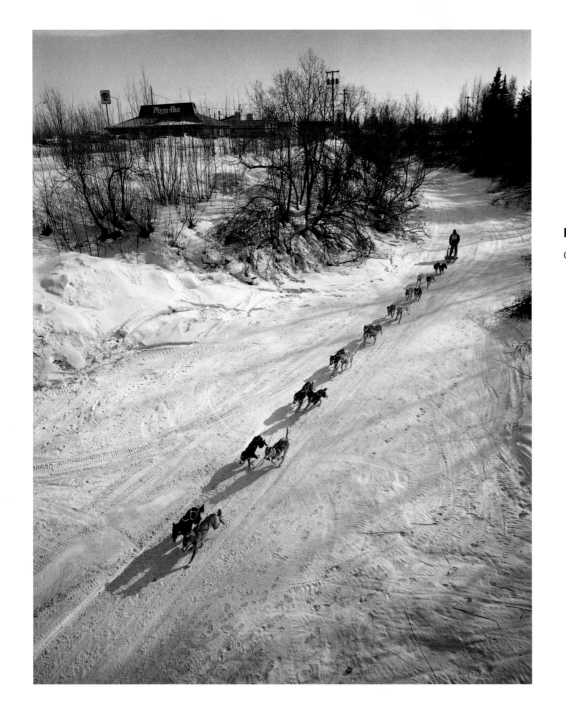

Fairbanks, Alaska

CHARLES MASON

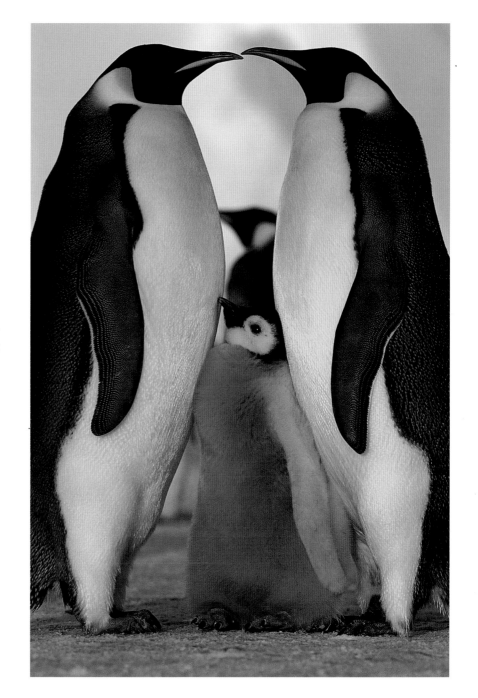

Halley Bay, Antarctica

ART WOLFE

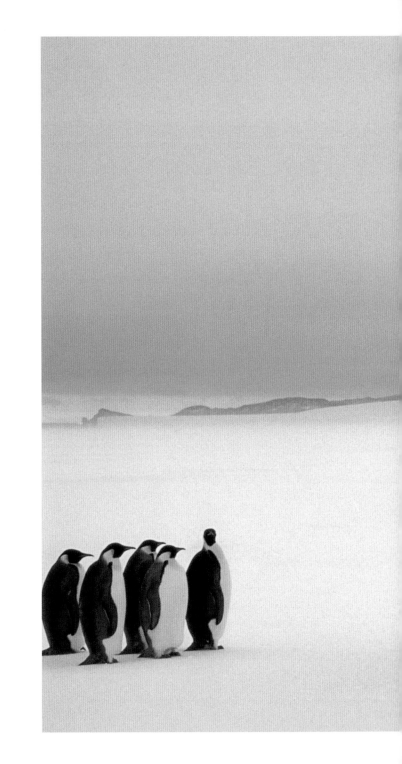

McMurdo Sound, Antarctica

NORBERT WU

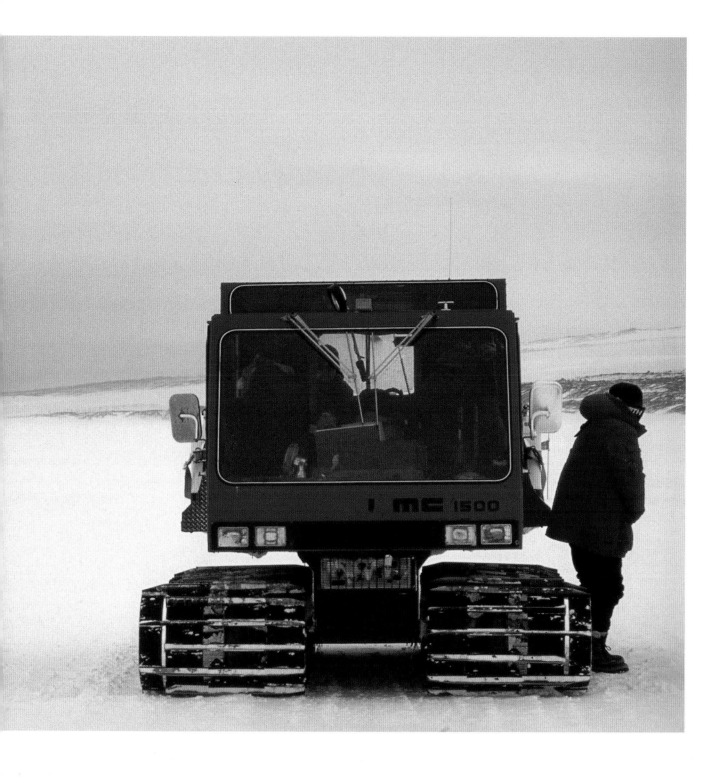

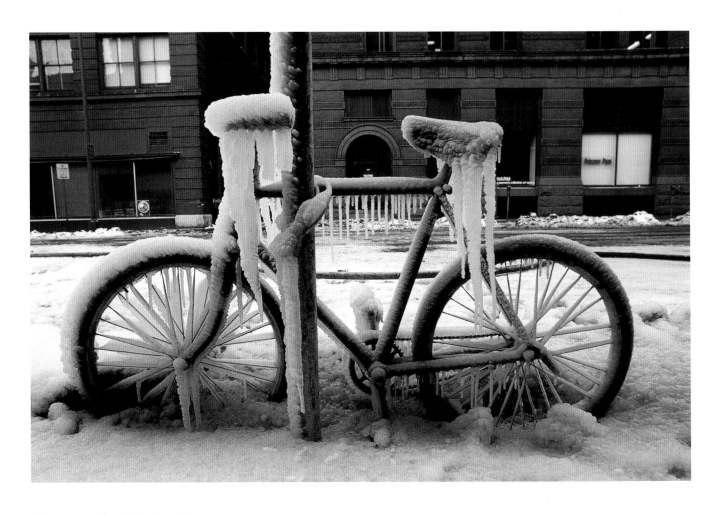

Minneapolis, Minnesota

ANNIE GRIFFITHS BELT/NATIONAL GEOGRAPHIC SOCIETY

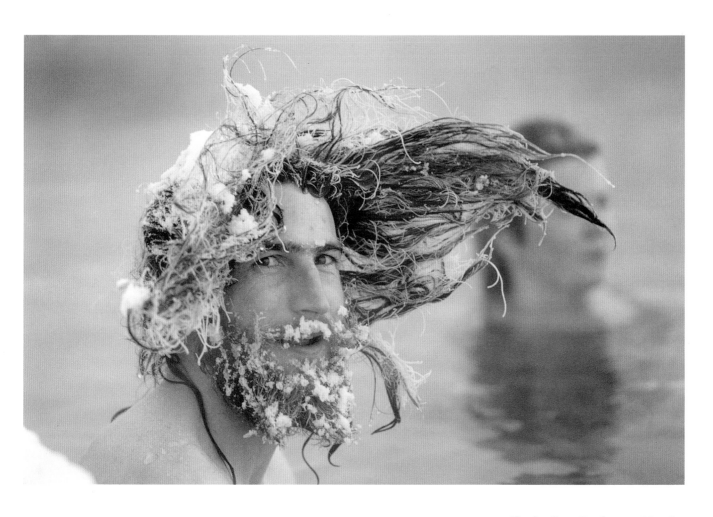

Circle Hot Springs, Alaska

STEVEN SEILLER/KEN GRAHAM AGENCY

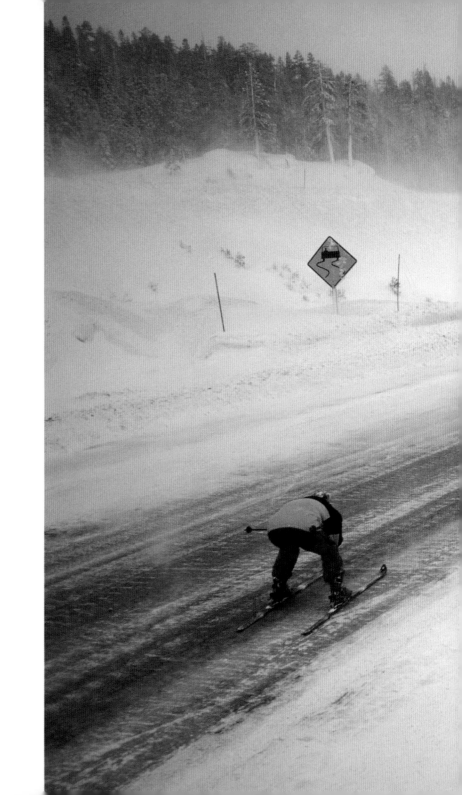

Donner Pass, California

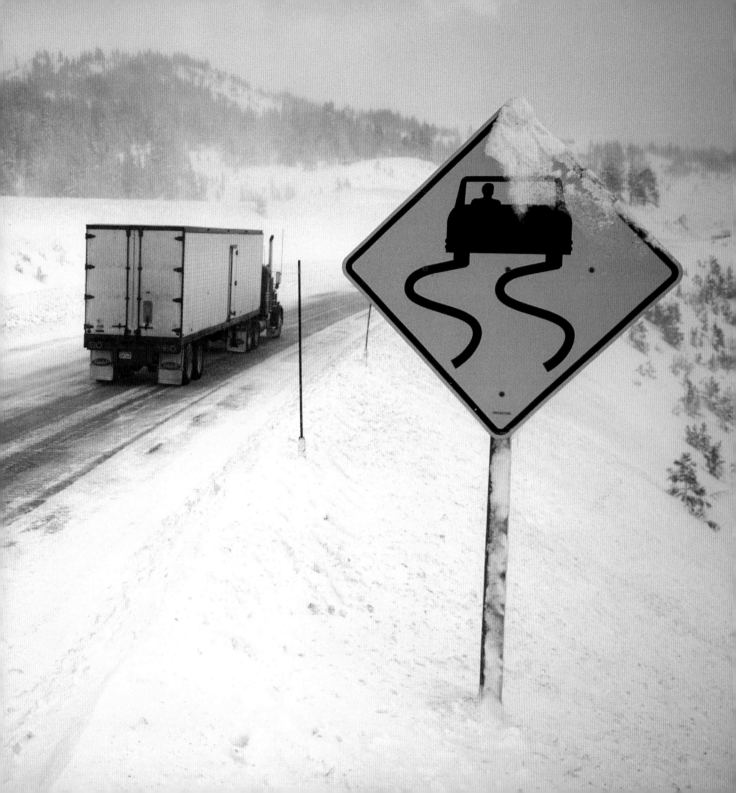

T H E P O L A R B E A R W A L T Z

Above the Sierra Nevada

KERRICK JAMES

Chamonix, France

DAVE NAGEL

and Other Moments of Epic Silliness

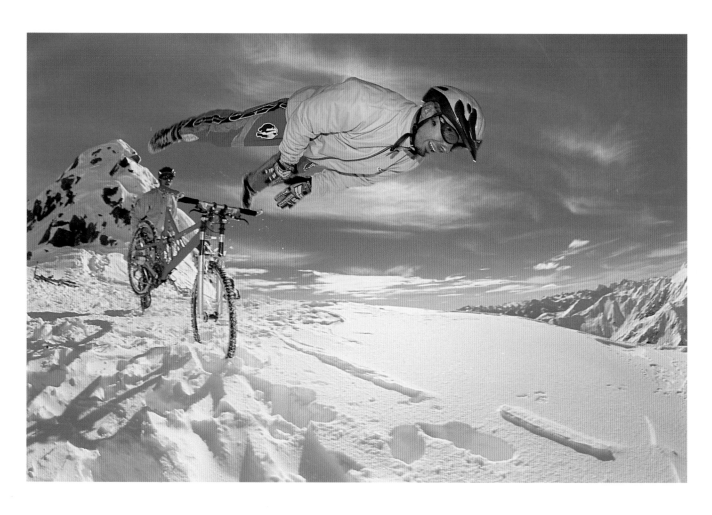

Val Senales, Italy

RONNY KIAVLEHN/LOOK

Tignes Alps, France

JEAN MARC BAREY/GETTY

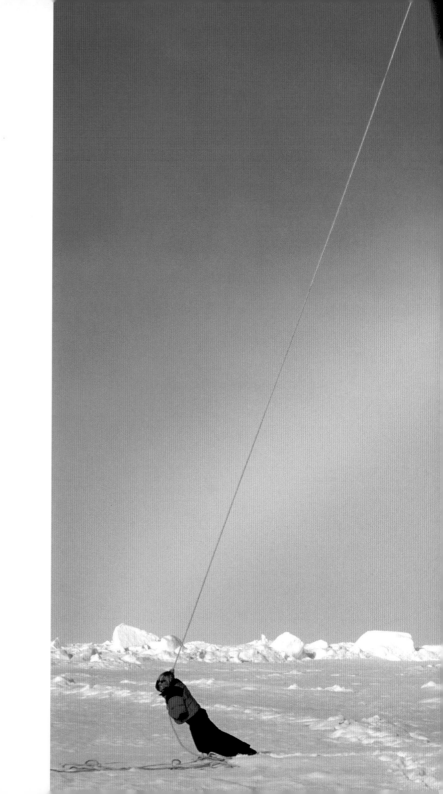

The North Pole

PER BREIEHAGEN

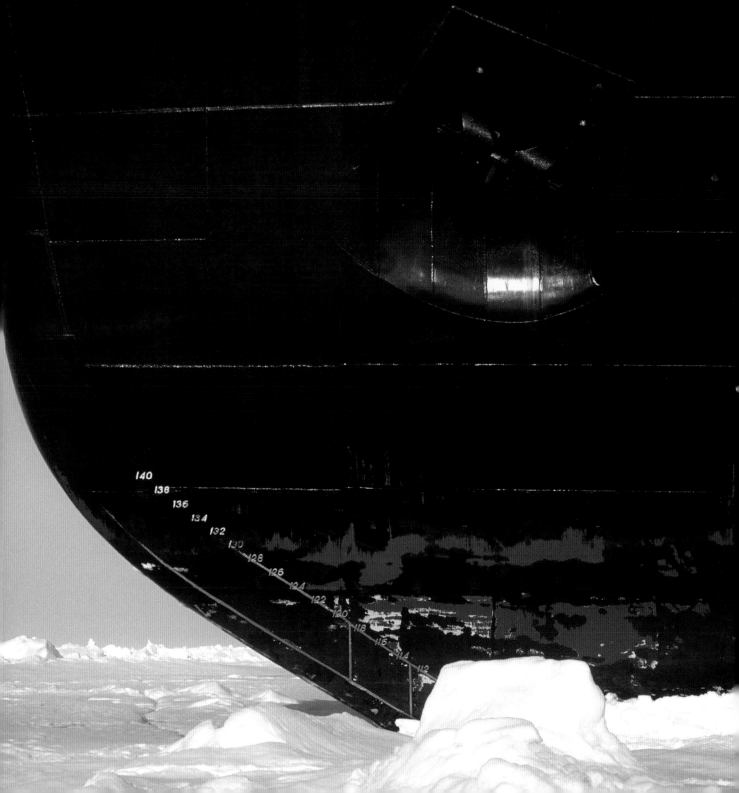

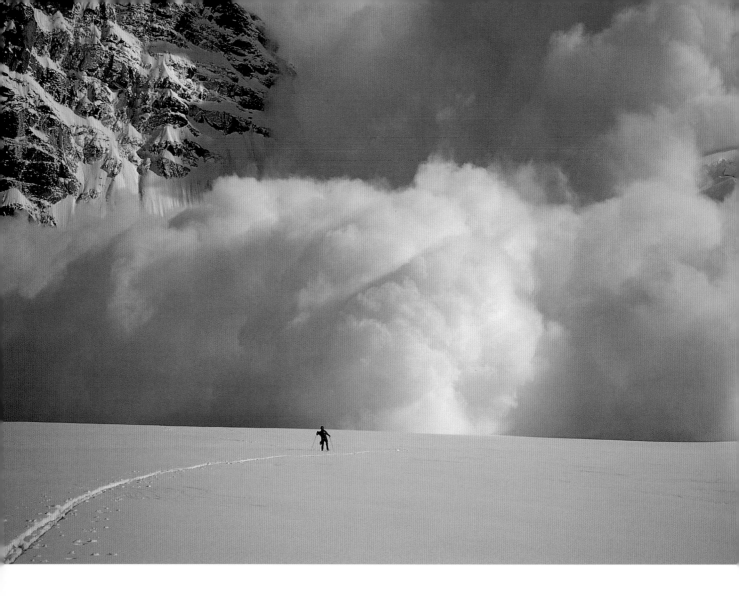

Mount Hunter, Alaska Range, Alaska

CHARLES MacQUARIE

Boston, Massachusetts

GARY LAND

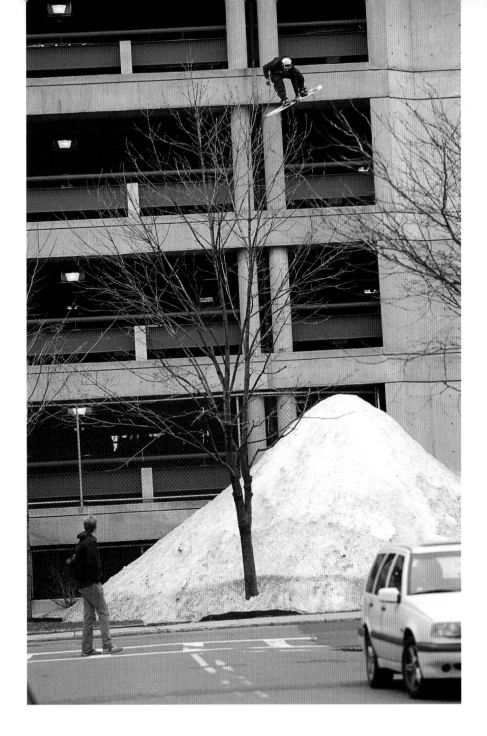

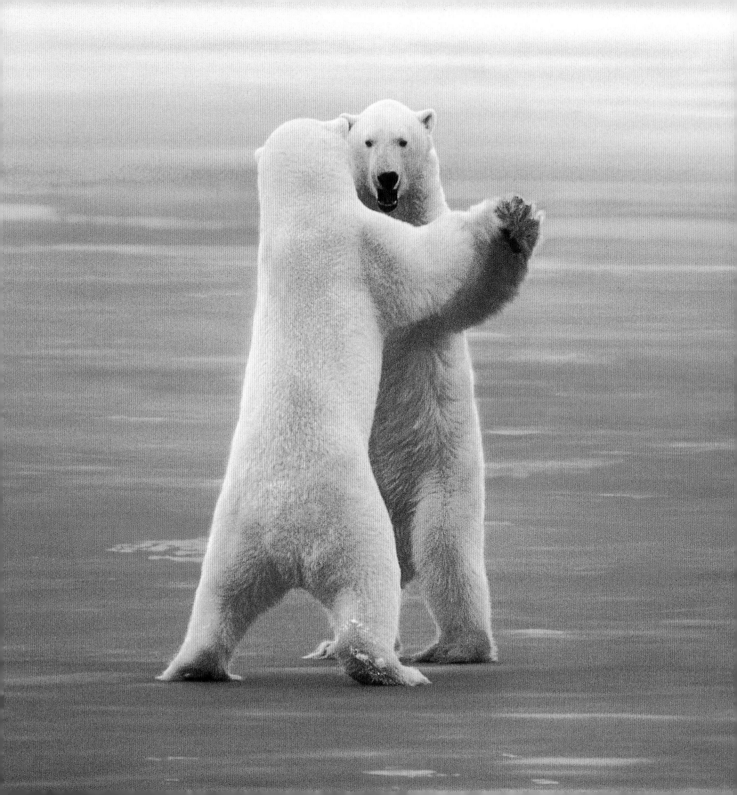

Hudson Bay, Canada
FRANS LANTING / MINDEN PICTURES

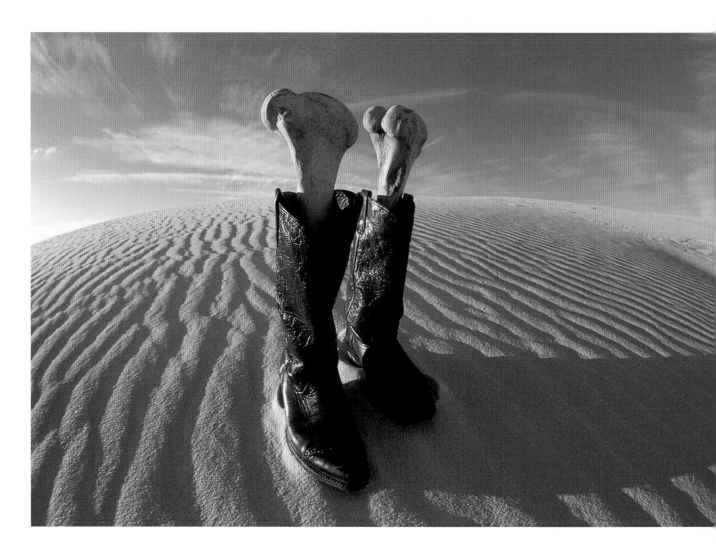

White Sands National Monument, New Mexico

JIM BRANDENBURG / MINDEN PICTURES

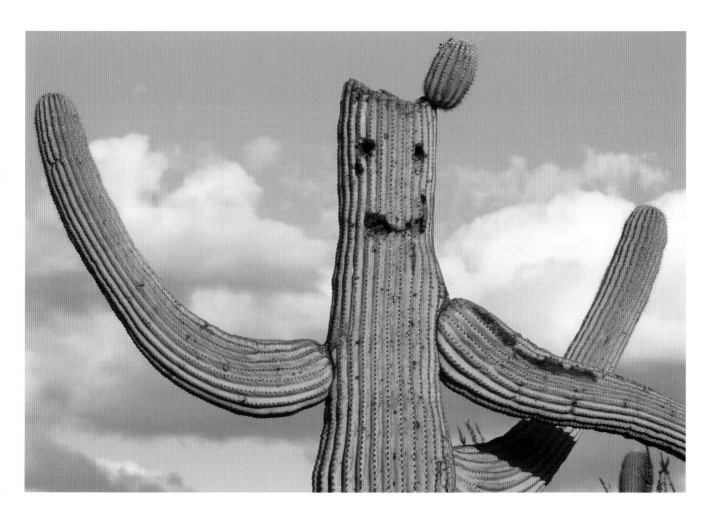

Saguaro National Monument, Arizona

JOE McDONALD/CORBIS

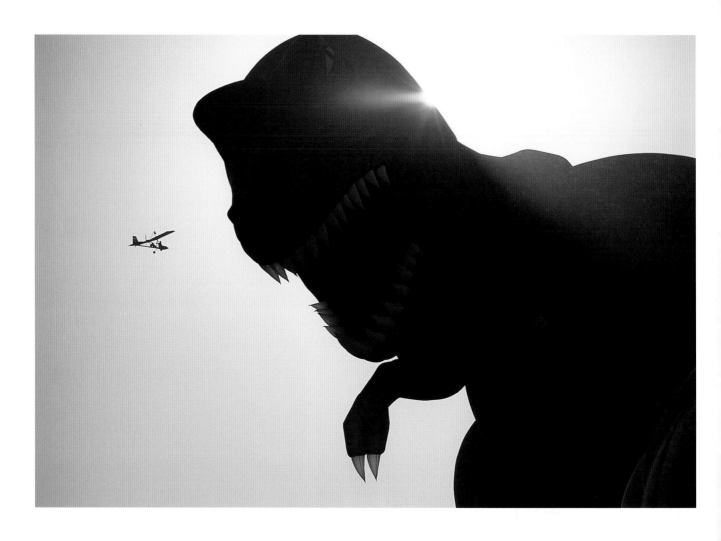

Driggs, Idaho

BRAD SCHWARM/JACKSONHOLEPHOTOS.COM

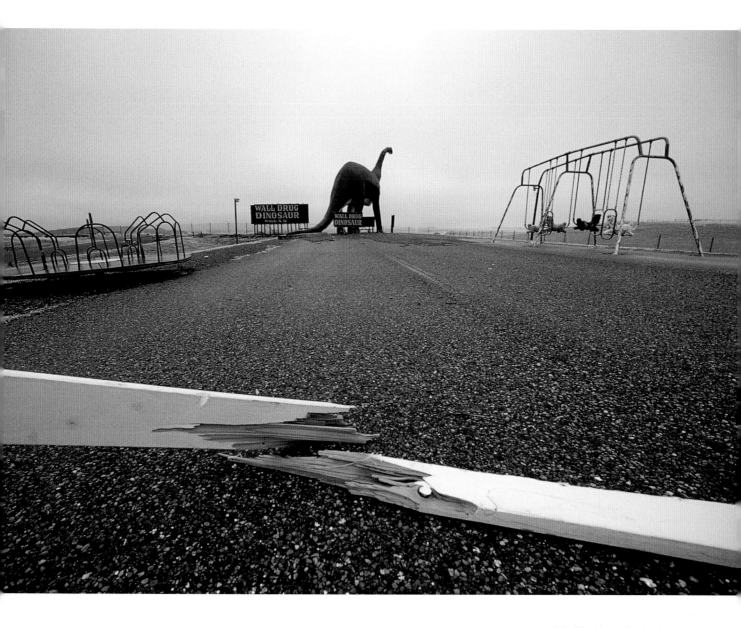

Wall, South Dakota

ANNIE GRIFFITHS BELT/NATIONAL GEOGRAPHIC SOCIETY

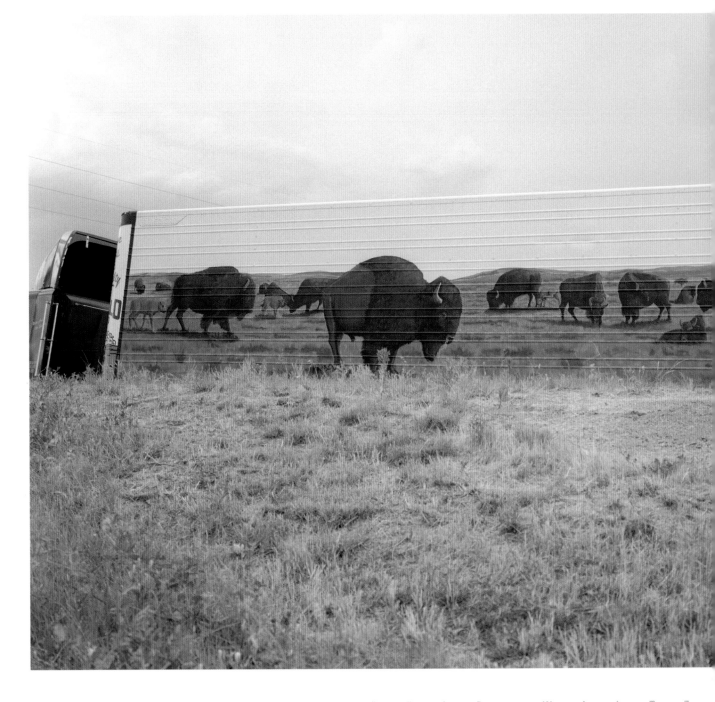

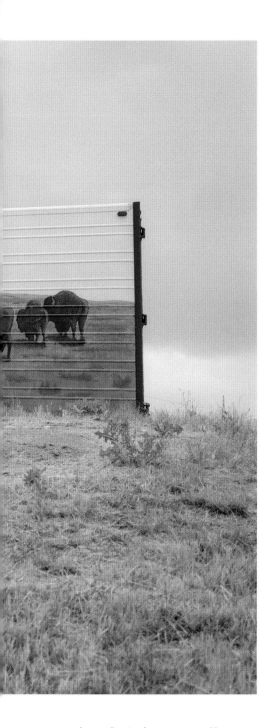

Greeley, Colorado

B FERRARO

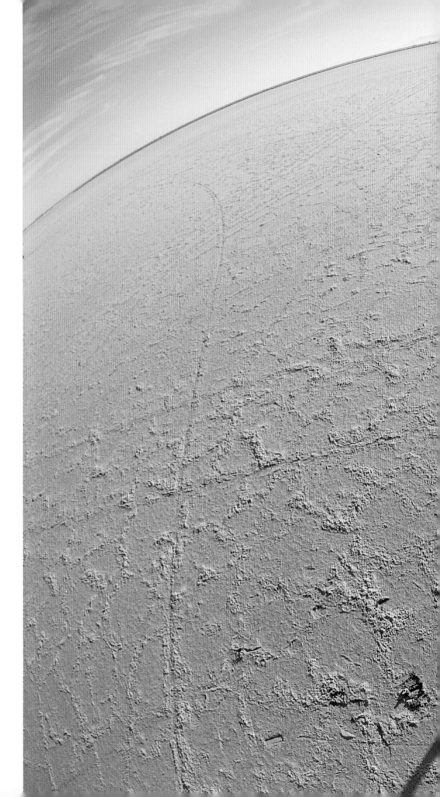

Bonneville Salt Flats, Utah

CAMERON LAWSON

Belalp, Switzerland

SCHWEIZ/MAGAZIN

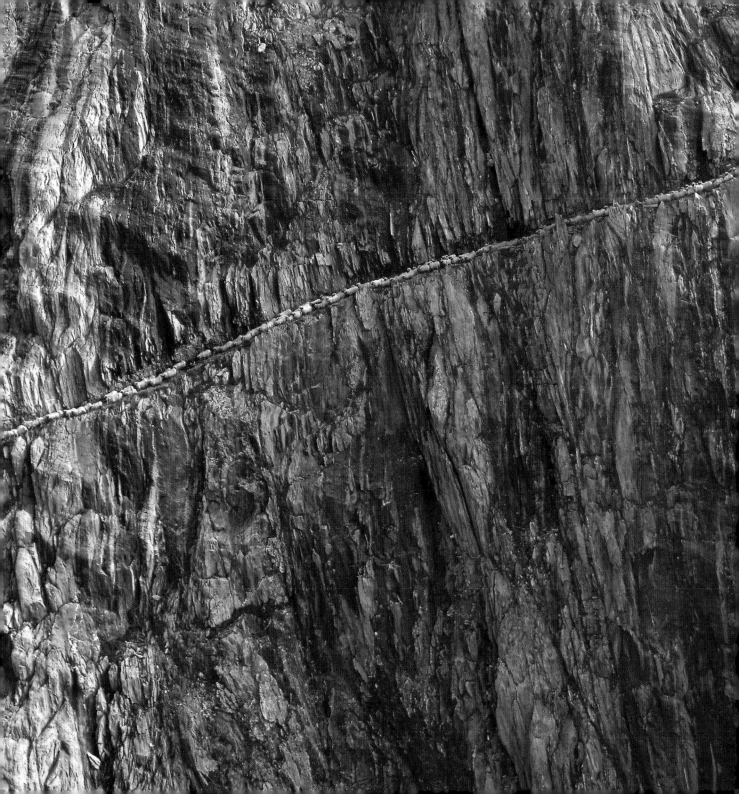

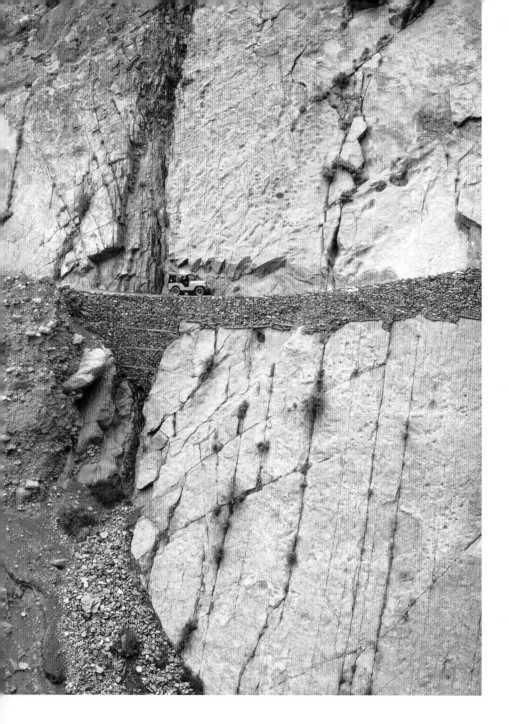

The Silk Road, Pakistan

RIC ERGENBRIGHT

Khyber Pass,
Afghanistan-Pakistan
Border

TERRENCE MOORE

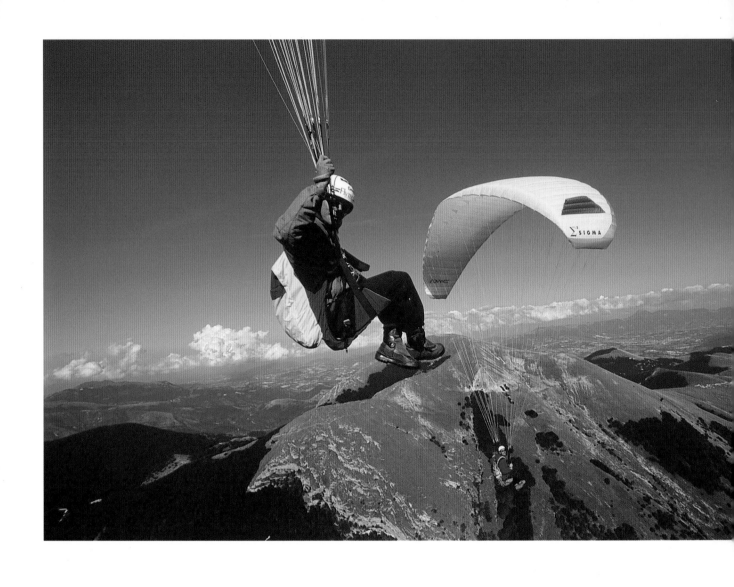

**Over the Bernese Alps,
Switzerland**

THOMAS ULRICH/ADVENTURE PHOTO

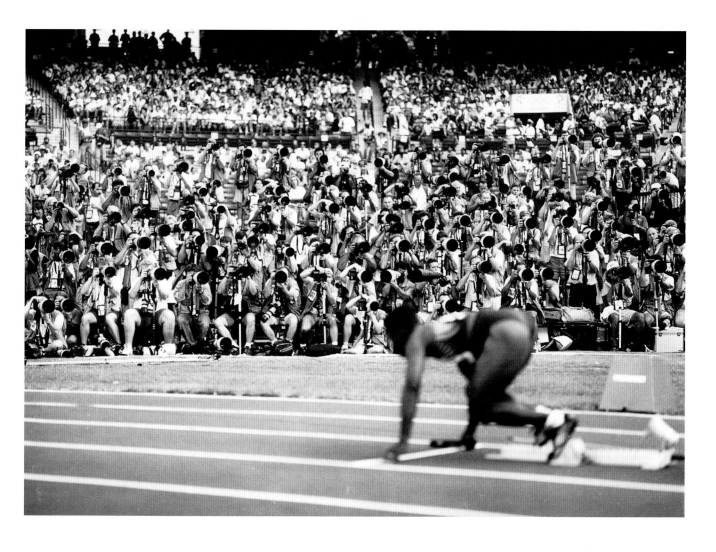

Atlanta, Georgia

DAVID BURNETT/CONTACT PRESS

Puna, Hawaii

TRACY FRANKEL

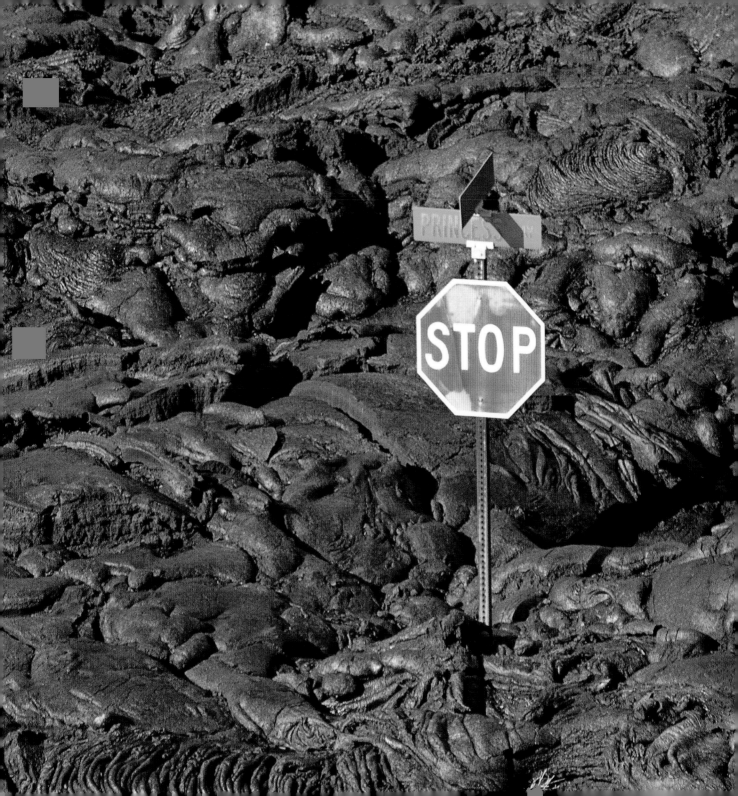

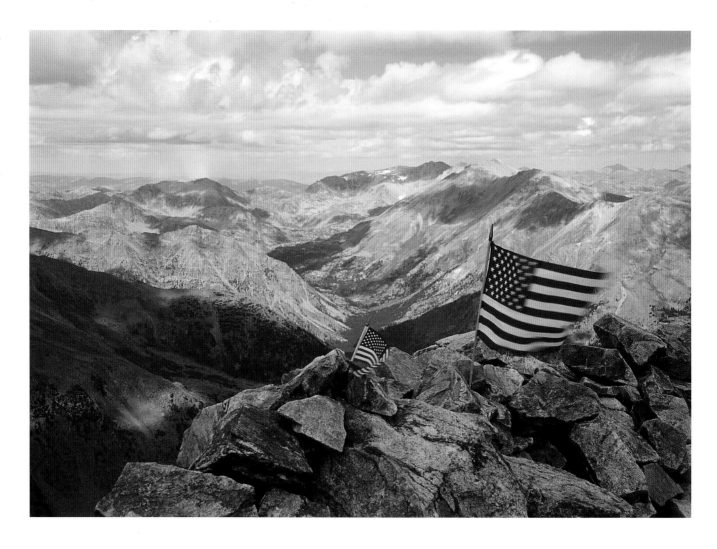

Mount Elbert, Colorado, September 16, 2001

DAVE SHOWALTER